Isabella Stewart Gardner

DOG LOVER

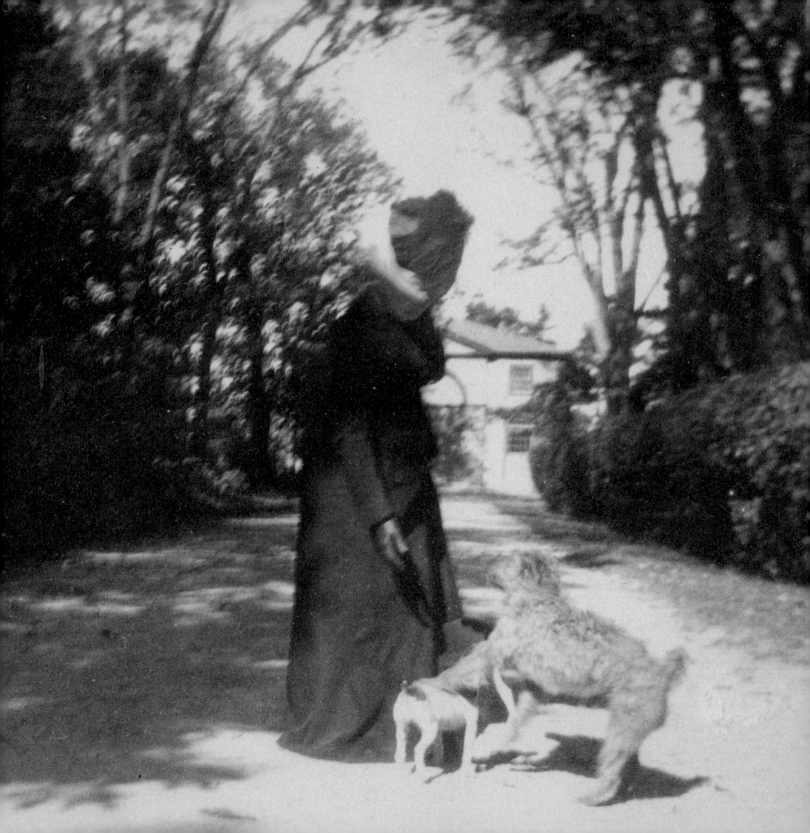

Isabella Stewart Gardner

DOG LOVER

Diana Seave Greenwald

ISABELLA STEWART GARDNER MUSEUM, BOSTON
PAUL HOLBERTON PUBLISHING, LONDON
2020

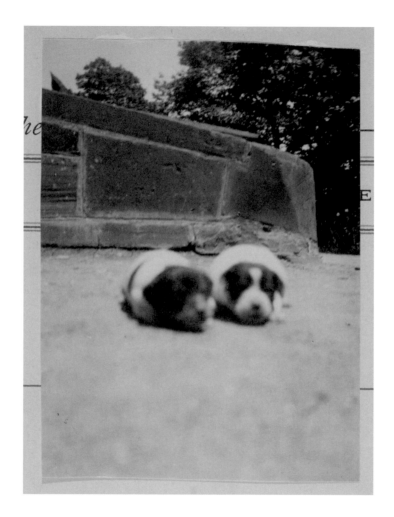

For Kitty Wink, Patty Boy, Foxey, and Rowley

ISBN 978-1-911300-96-0

Paul Holberton Publishing
89 Borough High Street, London SE1 1NL
WWW.PAULHOLBERTON.COM

Designed by Laura Parker
Printed by Gomer Press, Llandysul, Wales

FRONT COVER: Isabella with Kitty Wink, Patty Boy, and Another Fox Terrier Friend on the Roof of Fenway Court, from Guest Book Volume VI, p. 42, about 1900

FRONTISPIECE: Isabella Stewart Gardner and Dogs, from Guest Book Volume VI, p. 32, September 1901

DEDICATION: Fox Terrier Puppies, from Guest Book Volume V, p. 27, June 1899

INTRODUCTION: Isabella with Puppies, from Guest Book Volume IV, p. 39, August 1898

BACK COVER: Isabella and Kitty Wink on the Roof of Fenway Court, about 1901

Contents

Director's Foreword

Visitors to the Isabella Stewart Gardner Museum almost universally want to know one thing: what was Isabella like? Whether an overseas visitor here for the first time or a Bostonian who comes several times a year, there is a consistent thirst for information about our founder, her attitudes, her adventures in acquiring exceptional works of art, her sources of wealth, and the many ways she flouted social conventions to establish and run a major arts institution as a nineteenth-century woman. Isabella was a complicated person, like all of us, with many sides to her personality; while this book does not address all these questions, it does present a particularly charming aspect of Isabella that many may not expect: her love of dogs.

The same fierce woman who routinely went toe-to-toe with major museums and titans of industry to purchase masterpieces had a soft spot for animals, above all dogs. In this book, you will get to know Isabella's favorite pets, see the litters of puppies she bred and raised, and discover how her dogs were a comfort toward the end of her life. Isabella Stewart Gardner was a force to be reckoned with, but, like many people, she grins unabashedly in photos with cute puppies. I hope you enjoy learning about this exceptionally human side of our founder, as well as her adorable canine companions, as much as I did. And please don't let the subject matter fool you into thinking that writing about it was an easy task. For all of the work that went into this book, the many hours researching archival documents and photographs, I would especially like to thank its author, Diana Greenwald, Assistant Curator of the Collection at the Isabella Stewart Gardner Museum. I am also grateful to Shana McKenna, the museum's archivist, for her tireless efforts in preserving the records of Isabella's life—and canine loves.

PEGGY FOGELMAN
Norma Jean Calderwood Director

Acknowledgments

The idea for this publication originated with a book created by Alexandra Y. Bush during her time as an archives assistant at the Isabella Stewart Gardner Museum. Alexandra assembled images of Isabella and dogs—as well as descriptions of the founder and her pets—to create a book to use in service of one of the museum's Third Thursday events. One of the two copies of this small in-house publication ended up in the hands of our director, Peggy Fogelman, who immediately recognized that there would be broad demand for a book about Isabella and dogs. Therefore, without Alexandra's initial work and Peggy's insight, this book would not exist. Archivist Shana McKenna and Head of Collections Access Elizabeth Reluga helped me gather the photographs and archival materials for this volume. In the midst of a pandemic shutdown, Julia Featheringill came to the museum to complete new photography, making it possible to publish the book on time. The assistance of all three was essential. In fact, the entire collections team at the museum contributed by sending me all sorts of dog-related stuff that they came across while I was writing. Finally, William and Lia Poorvu Curator of the Collection Nathaniel Silver provided a critical first round of edits of the text, which significantly improved its readability.

DIANA SEAVE GREENWALD
Assistant Curator of the Collection

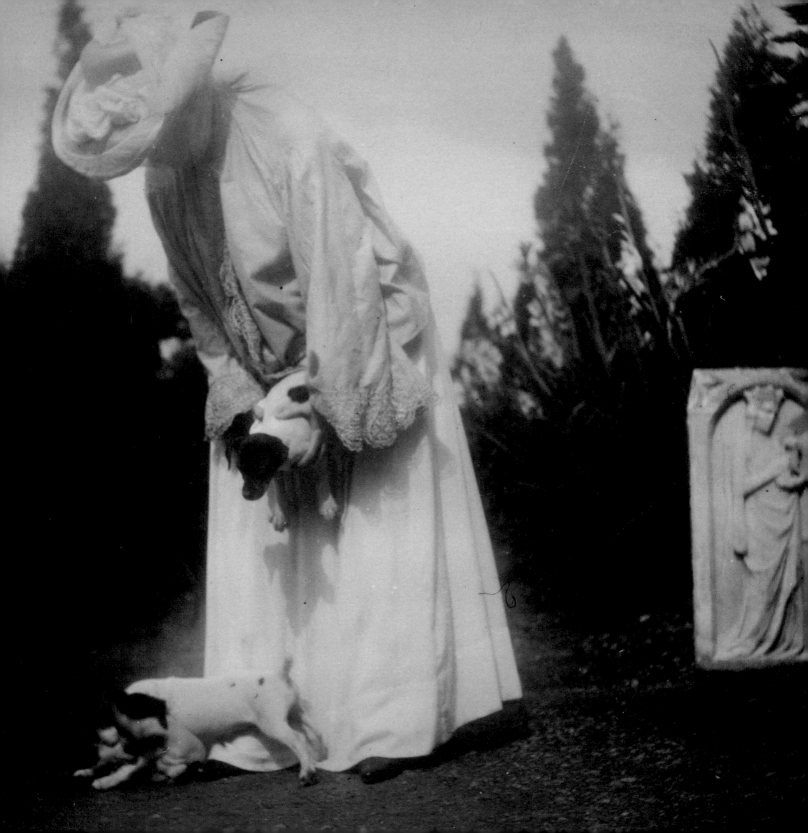

Introduction

The Dutch Room in the Isabella Stewart Gardner Museum is home to some of the institution's greatest paintings, including Rembrandt's *Self-Portrait, Age 23* (1629) and *Thomas Howard, Earl of Arundel* (about 1629–30) by Peter Paul Rubens. On a table near the room's main entrance, two small Chinese tomb figurines appear in the company of Isabella Stewart Gardner's Dutch and Flemish masterpieces: a diminutive dog and pig from the third century BCE (fig. 1). The pair originally stood near *The Concert* (1663–66) by Johannes Vermeer. That Isabella chose to install such precious images of animals alongside her most prized canvases is hardly a coincidence. She loved art *and* animals. She owned horses and frequently visited the zoo—one anecdote even describes her taking a toothless lion named Rex for a walk during a particularly eventful visit.[1] Dogs were, however, her favorite.

Isabella was a dog lover, as amply shown by her museum's collection, her personal correspondence, and her extensive archives. Illustrated with historic photographs and supported by quotes from her and people who knew her, this book tells the story of Isabella and dogs. It focuses particularly on four of her dogs whose names we still know: Kitty Wink and Patty Boy —both terriers—and Foxey and Rowley, two collies. Isabella specifically referred to this canine quartet in her final will and testament. While the majority of the will is dedicated to setting rules for the governance of the museum, one article of the document is devoted to her dogs (and three favorite horses). It states:

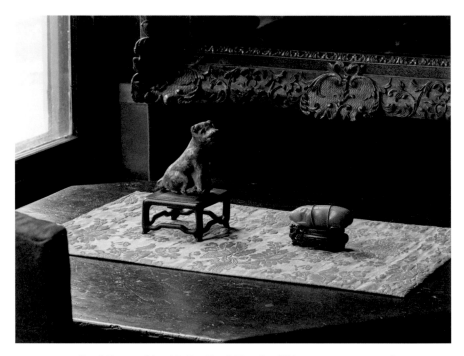

1. Dutch Room table with Dog Tomb Figurine (Chinese, 206 BC – AD 220)
and Pig Tomb Figurine (Chinese, third century BC)

All the residue of my estate, real and personal, I give to the [Cotting School] and the Massachusetts Society for the Prevention of Cruelty to Children, the Animal Rescue League of Boston, Massachusetts, and the Massachusetts Society for the Prevention of Cruelty to Animals, in equal shares, I hereby intend that the gift to the Animal Rescue League of Boston shall be in memory of the dogs Foxey and Rowley, and I hereby direct that the gift to the Massachusetts Society for the Prevention of Cruelty to Animals is on the condition and subject to the charge that the said Society shall expend each year the sum of seventy-five dollars for a free stall in memory of three horses, Dolly, Pluto, and Lady Betty, and that it shall expend each year the sum of thirty-five dollars for a free kennel in memory of the dogs Kitty Wink and Patty Boy.[2]

The Massachusetts Society for the Prevention of Cruelty to Animals

OFFICES: 180 LONGWOOD AVENUE, BACK BAY STATION, BOSTON $110 —

The Massachusetts Society for the Prevention of Cruelty to Animals acknowledges the receipt of ——— One Hundred Ten ——— Dollars from Mrs. John Lowell Gardner, for one free box stall for horses in memory of "Dolly, Pluto and Lady Betty," and one free kennel for dogs in memory of "Kitty Wink and Patty Boy"

May 1919 — May 1920

Boston, May 10 1919

2. Receipt from the Massachusetts Society for the Prevention of Cruelty to Animals for Isabella's donation in honor of her dogs Kitty Wink and Patty Boy, 10 May 1919

Appreciating, caring for, and loving animals—particularly dogs—was important to Isabella. The receipt for Gardner's donation to the Massachusetts Society for the Prevention of Cruelty to Animals (MSPCA) demonstrates her commitment to fulfilling the promises laid out in her will (fig. 2). Founded in 1868, the MSPCA is the second-oldest humane society in the United States and was part of a movement dedicated to the protection of animals that first developed in Victorian Britain and then gained momentum in the United States. The Animal Rescue League of Boston, Isabella's other chosen charity, was established in 1899 as part of the same growing interest in animal welfare. Then, as now, both organizations took care of animals without homes and who were injured or abused.

As the final section of this book explores, Isabella not only cared for her own dogs but paid close attention to celebrity dogs around the world. She followed news about internationally known canines and kept photographs of her famous friends posing with their own four-legged companions. Throughout Isabella's life, dogs and art were recurring themes, and she would no doubt be thrilled to see her museum dedicating a book to her canine interests.

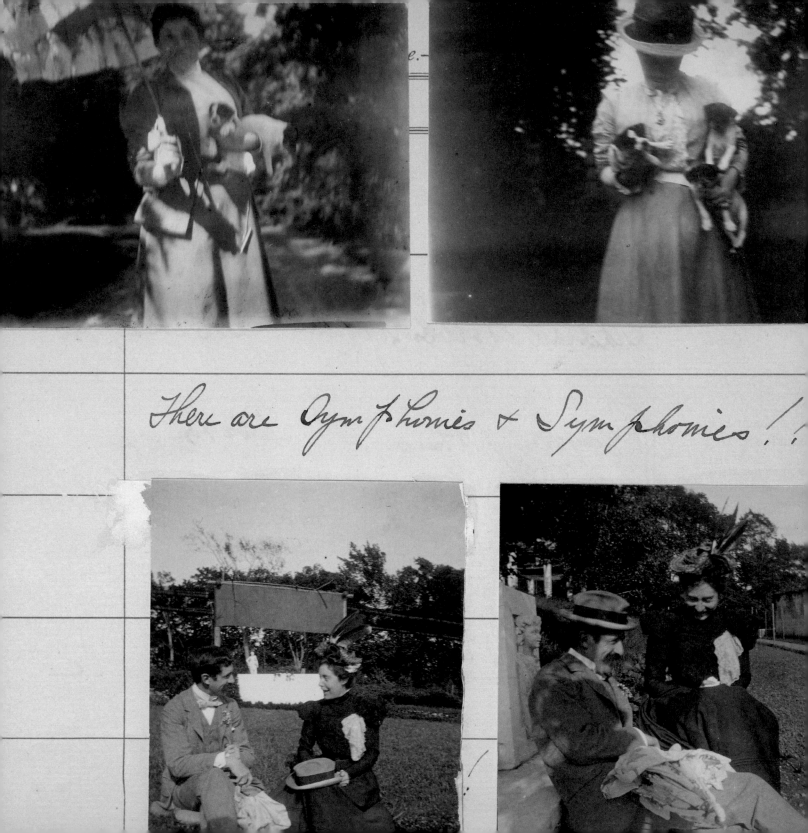

There are Symphonies & Symphonies!!

A Passion for Fox Terriers

As Hugh Dalziel boldly began *The Fox Terrier, and All About It,* "Evidence has been [shown] to prove that the Fox Terrier, if not *the* most popular of all breeds, at any rate occupies a very exalted position in the hearts of the dog-loving public."[3] Isabella would have heartily agreed. She kept extensive guest books from 1893 to 1919 that not only record which friends and family came to visit her but also double as photo albums and scrapbooks. May 1896 opens with the arrival of some decidedly adorable guests: fox terrier puppies. One month later, an infant fox terrier is the star of a dedicated photo shoot (fig. 4). This puppy lies in the grass at Green Hill—Isabella's home in Brookline, Massachusetts, near Boston—with the pianist George Proctor, whose musical career Isabella helped to support. In another photo, the same pup is peeking over Isabella's shoulder. (Isabella here wears a veil—as she typically did in the sun in order to protect her skin.)

Isabella was probably involved in breeding smooth-haired fox terriers at Green Hill. In the years after 1896, come spring or summer, the arrival of more puppies continues to feature prominently in her guest books (fig. 3). Photographs show the pups playing and romping in the grass (figs. 5, 6, 7) and held in Isabella's arms (fig. 25). She described caring for the puppies in several letters. Writing to her art advisor Bernard Berenson in 1900, she said: "Part of my morning's work has been to try to induce two 9 days old fox terrier pups to open their eyes again. They did once; and then clapped them to, with a vim that seemed to say that the box they found themselves in was not the ideal they had come to this world to see!"[4] The two little ones

3. Isabella and Friends with Puppies, from Guest Book Volume IV, p. 15, Summer 1898

e exprest, Welcome the coming, speed th

EVENTS ✦ ADVENTURES

The Pop —	F
"	From the fullness of the mouth (good dinner) the heart cannot
A high stool	"I know, Sir; but you're very young" Giltermer.
Cambridge	The last time but one 'Combien j'ai douce souvenance'

4. George Proctor and Isabella with Puppies, from Guest Book Volume III, p. 51, June 1896

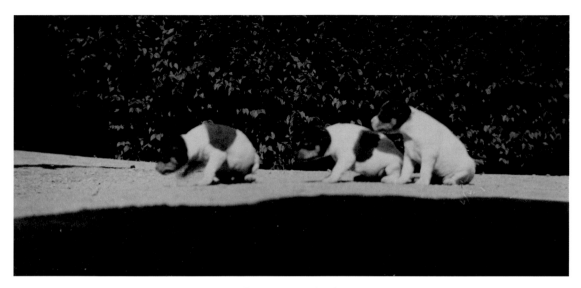

5. Fox Terrier Puppies, from Guest Book Volume IV, p. 24, June 1898

OVERLEAF
6. Guest Book Volume V, p. 34, July 1899

she described to Berenson might have resembled those featured in photographs in her 1899 guest book. The pair are at most a few weeks old (fig. 6).

Isabella even empathized with her fox terrier puppies. Convalescing in Brookline in March of 1898 after she broke her leg from a fall down the stairs at home—an event that made the front page of the *New York Times*—she wrote in another letter to Berenson: "I am beginning to walk! I am a droll sight—I drive out to Brookline nearly daily—and yesterday I walked in the spring garden. Every tuft in the grass reminded me of a little puppy I had last year, who fell down whenever he came to an impediment 2 inches high. When my walk of three minutes was over I was as tired as if I had walked 100 miles!"[5] We cannot know which of the puppies was so overcome by these small barriers. However, a guest book photograph from around the same time features a little one who is barely taller than the lawn (fig. 7).

NAME	RESIDENCE	ARRIVED
...nnie Macomb	*Washington D.C.*	*July 3.*
...eorge Proctor	*Brookline*	*July 3rd*

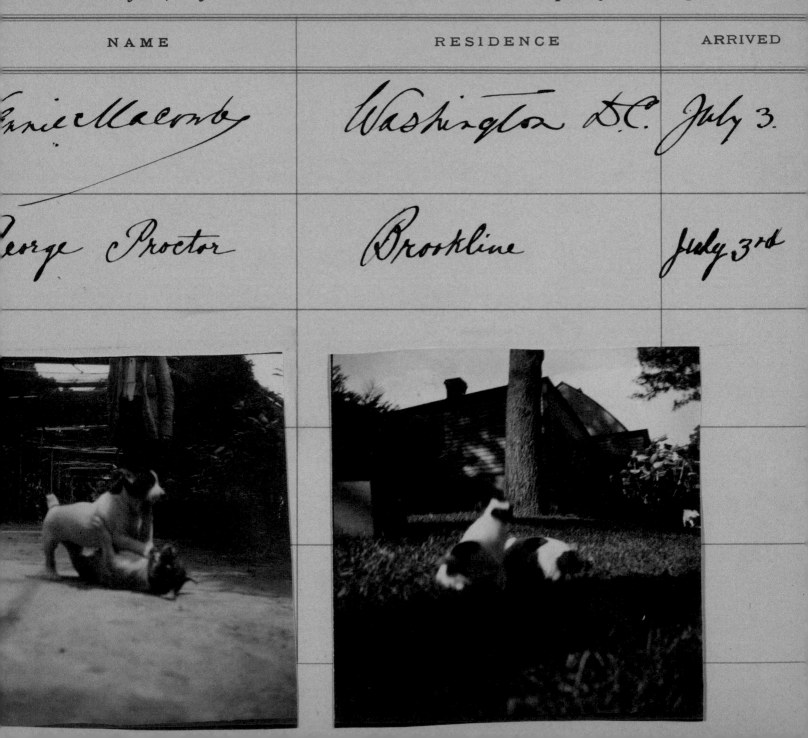

LEFT	GOING TO	EVENTS ❖ ADVENTURES ❖
	Kendal Green with messages to bad people	If I could make all I should like to I remain a year
⟨...⟩	little red house	I love anniversaries with myself many

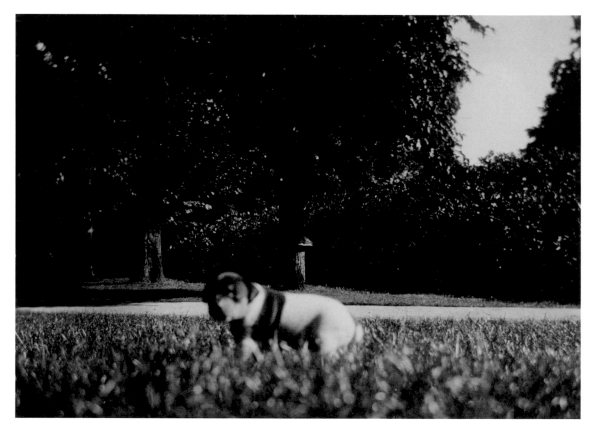

7. Fox Terrier Puppy, from Guest Book Volume IV, p. 24, June 1898

Of all the smooth-haired fox terriers that appear, Kitty Wink was Isabella's clear favorite. Kitty, as Isabella called her, was likely one of the first visitors to the museum. Photographs show the terrier at Fenway Court—the name of the museum from 1903 to 1924—shortly after the building's completion (back cover).

Comparisons to Kitty Wink were clearly meant as a compliment. Writing to Mary Berenson, Bernard's wife, Isabella gushed:

> [*You sent*] *such an enchanting letter. So you have chucked duty and are off for that … most desired and wished for fun, a journey up and down … beloved Italy. Your letter came just in time. I had taken to tears from worries and vexations of every kind. I only wonder that it (your letter) didn't make me hate you from pure envy! But it didn't, it only sent me to dreamland, from which there are days when I wish there was no awakening …. My little dog Kitty is like you. She has just broken loose and gone off on a tear.*[6]

Hopefully Mary realized this description of her similarities to a dog was meant to flatter rather than insult her.

Kitty Wink was not a solo act. Patty Boy, who was a larger wire-haired terrier of indeterminate breed, was often her partner in crime, and photographs show the two terriers as a dynamic duo never far from Isabella's side. They posed for semiformal portraits with their owner, wandered around Green Hill in all seasons (figs. 8 and 9), and played with another friend at the museum construction site (front cover).[7] In addition to their joint antics, they were memorialized as a pair in Isabella's will (see Introduction).

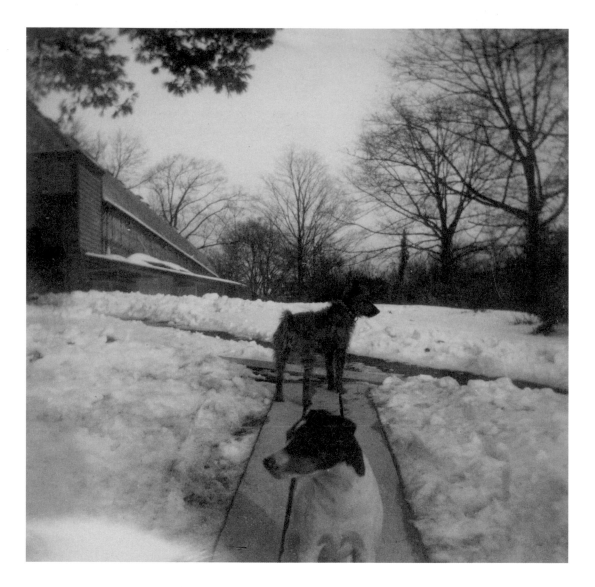

8. Kitty Wink and Patty Boy, from Guest Book Volume VI, p. 39, Winter 1901

9. Kitty Wink and Patty Boy with Isabella, from Guest Book Volume VIII, p. 40, Summer 1905

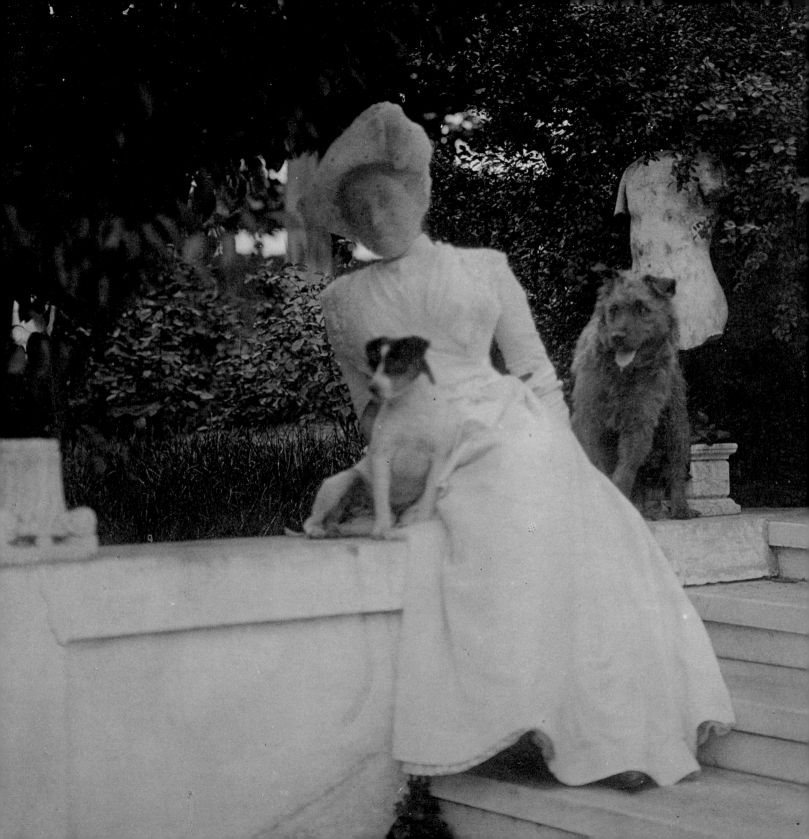

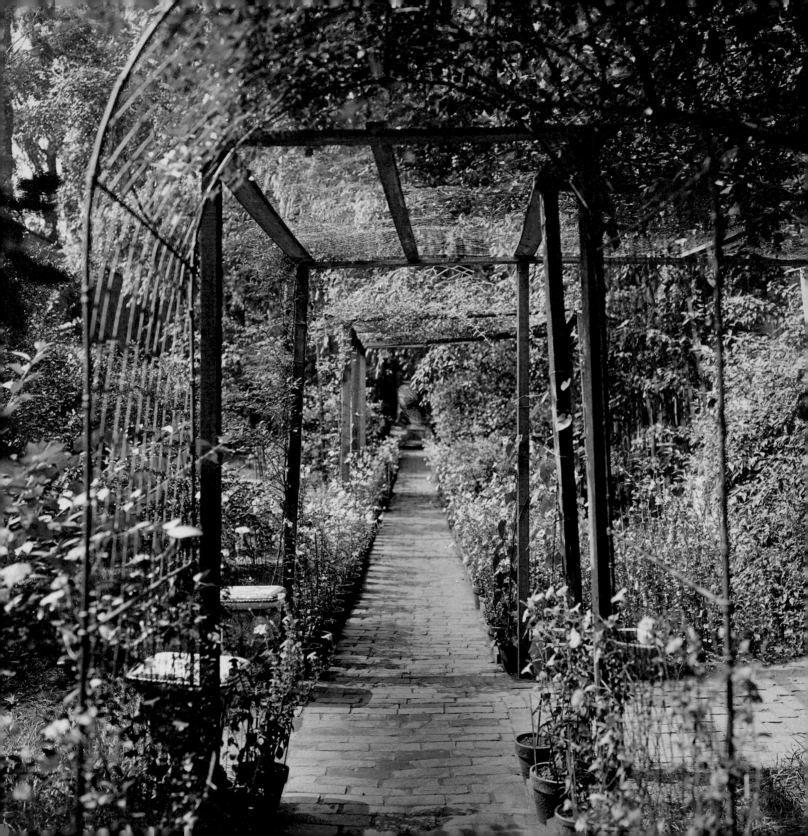

Foxey and Rowley

Kitty Wink and Patty Boy were not the only dogs acknowledged with charitable donations in Isabella's will. Collies Foxey and Rowley (sometimes spelled Roly or Rolly) were also honored in this way. However, unlike Kitty and Patty, who seem to have been Isabella's companion dogs and traveled with her from residence to residence, Foxey and Rowley likely lived full-time at the museum. Surviving photos of the pair show two smiling collies (fig. 11)—sometimes alongside a smiling Isabella (fig. 12).

When the museum was built, Isabella created an apartment for herself on the building's fourth floor. At the time the institution opened in 1903, the apartment was one of three residences she owned and occupied in the Boston area. The others were her home on Beacon Street (sold in 1904) and Green Hill in Brookline. However, she sold the Brookline property in 1919 and "planned to spend the rest of her days at Fenway Court," where Foxey and Rowley were her companions.[8]

Late in Isabella's life, after she had suffered a stroke in 1919 and her movement was limited, Morris Carter—the museum's first director and Isabella's first biographer—wrote that she still took advantage of good weather, with a dog at her side. "When summer came she went out in the automobile every morning, and spent the afternoon in the garden with her … old dog Roly at her feet."[9] The Monk's Garden, accessible through the Chinese Loggia, is located on the east side of the museum (fig. 14).

10. Thomas E. Marr & Son (active Boston, about 1875–1954), Monk's Garden, Isabella Stewart Gardner Museum, 1921

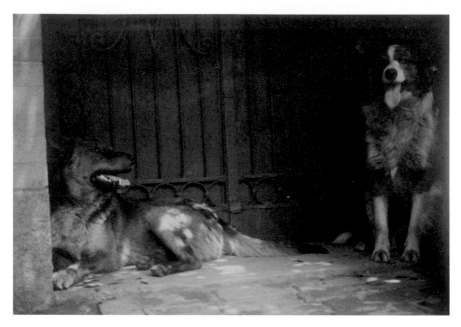

11. Rowley and Foxey, from Guest Book Volume VIII, p. 40, 1907

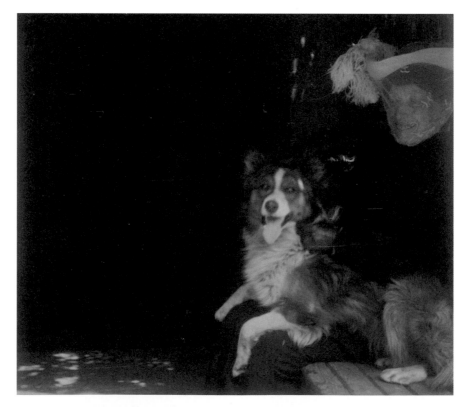

12. Rowley and Foxey with Isabella, from Guest Book Volume VIII, p. 40, 1907

Although it was redesigned in 2012, photographs from the 1920s show what it probably looked like when Isabella was lounging there with Rowley (fig. 10). Featuring trellised pathways and floral borders, it was a lush refuge for Isabella and her collie companion.

As Isabella aged, so too did her dogs. Carter described how "during the night of July 16 [1920] word was brought to her that Roly was dying: in a fever of haste she was carried down to the garden and sat by him till the end."[10] She buried both Foxey and Rowley in the grounds of the museum, their grave markers painted on the south wall of the property (fig. 13). These portions of the brick wall remain in storage today.

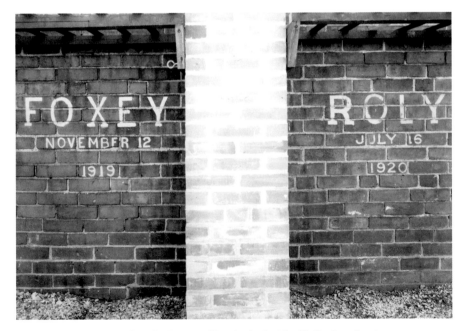

13. Grave Markers for Foxey and Rowley in the Monk's Garden, about 1940

OVERLEAF
14. Monk's Garden viewed from the Chinese Loggia, 2015

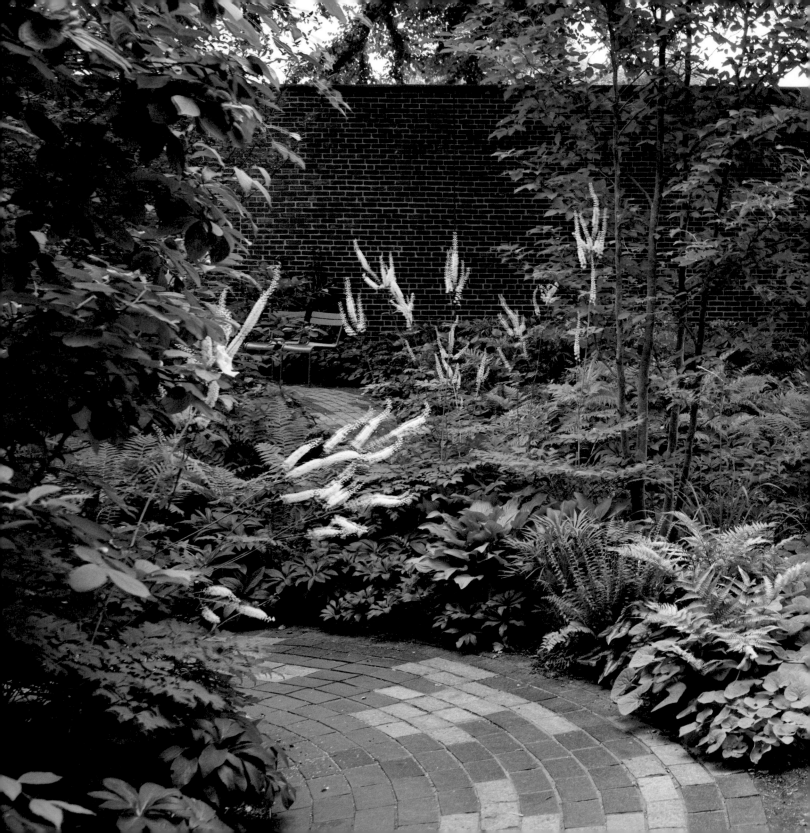

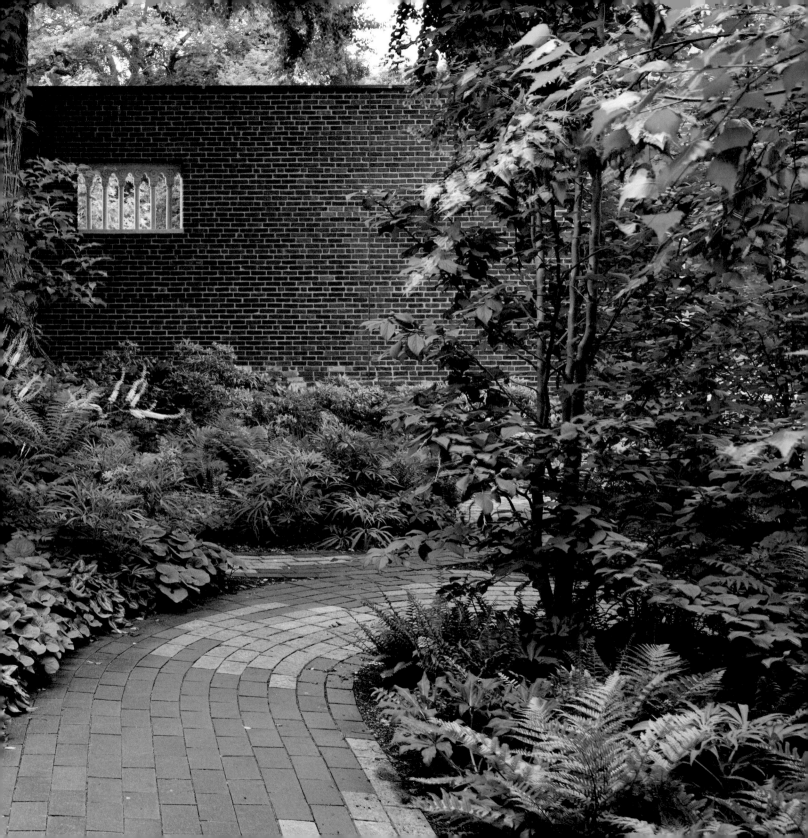

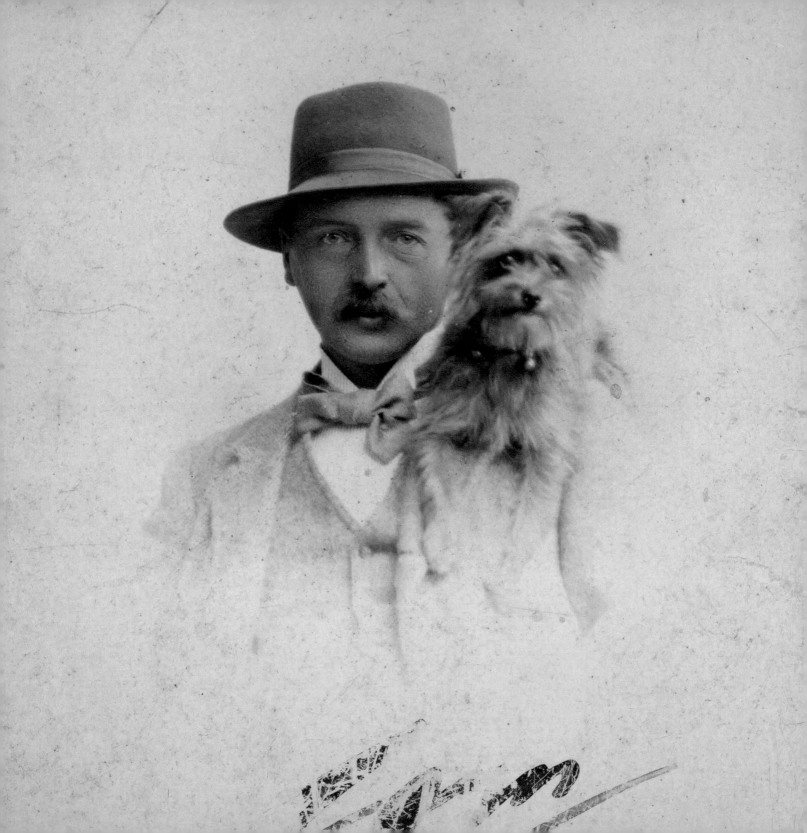

Dogs of the Rich and Famous

Isabella not only loved her own dogs but eagerly followed the lives of others—often those of notable people. Her archives preserve many photographs of famous canines and clippings of articles about them. These include a picture of German statesman Otto von Bismarck walking his imposing mastiffs (fig. 16) and photos of Isabella's famous friends—such as author Henry James, musician Charles Loeffler, and polo star Louise Eustis Hitchcock—posing with their pets (fig. 17–19). The cutest of them all may have been Mouche (fig. 15), who sat for a formal photographic portrait with his owner, the painter Anders Zorn, one of Gardner's close friends and maker of one of her iconic portraits. Painter and pup share a similar stare, and maybe similar mustaches.

Among these notable canines, the most famous was Caesar, the wire fox terrier who belonged to King Edward VII of England and traveled everywhere with the monarch (fig. 20). The terrier, greatly distressed after the king's death in 1910, secured international fame when he marched in the funeral procession of his late owner (fig. 22). Shortly after the funeral, Maud Earl—an English artist noted for her paintings of dogs—authored a bestselling book called *Where's Master?* under Caesar's name. Isabella, who loved both royalty and fox terriers, owned a copy of the book (fig. 21). Why did Isabella keep images of famous people with their dogs? Possibly because seeing world leaders and influential people with their pets

15. Hjalmar Klingvall (active Mora, Sweden, 19th century),
Anders Zorn with Dog, Mouche, 1894

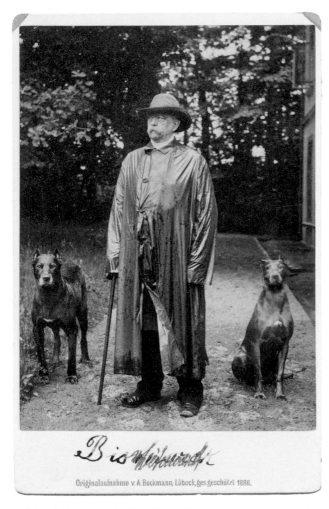

16. Alcide Bochmann (active Lübeck, Germany, late 19th century),
Otto von Bismarck with His Mastiffs, 1886

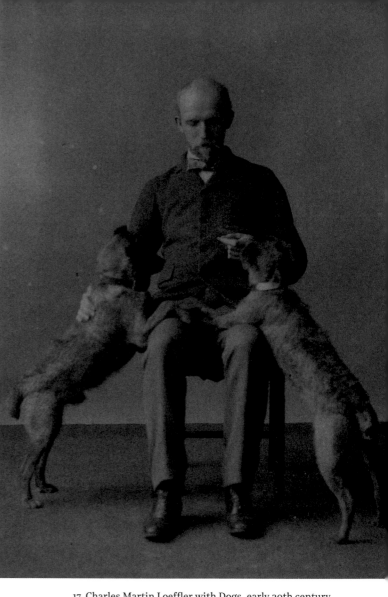

17. Charles Martin Loeffler with Dogs, early 20th century

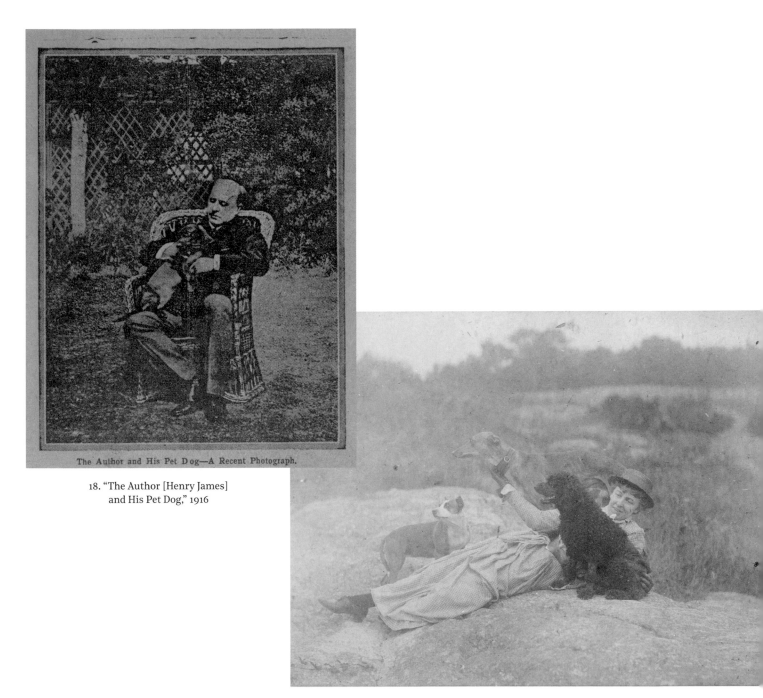

The Author and His Pet Dog—A Recent Photograph.

18. "The Author [Henry James] and His Pet Dog," 1916

19. Louise Eustis Hitchcock and Dogs, early 20th century

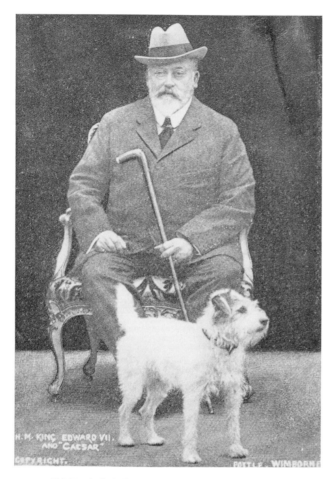

20. Job Pottle (Wimborne, 1856–1947), "Friend of Royalty,"
King Edward VII and His Dog Caesar, about 1908

21. Maud Earl (London, 1864–1943, New York, author) and Hodder &
Stoughton (established London, 1868, publisher), *Where's Master?*
by CÆSAR, the King's Dog, 1910

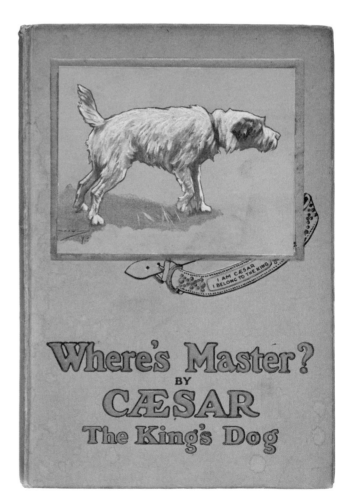

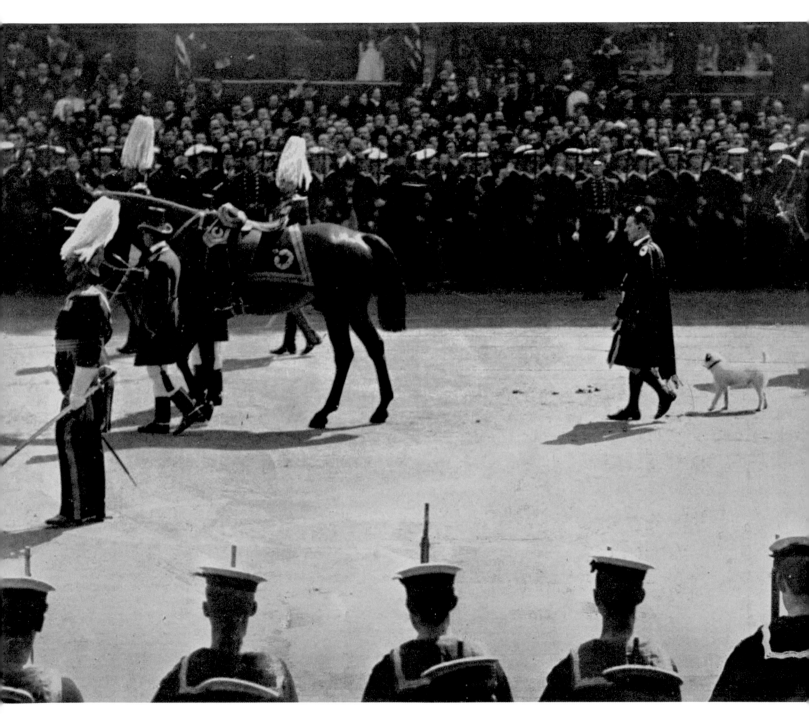

22. Funeral Procession of King Edward VII, with Caesar and the King's Horse,
20 May 1910. The Royal Collection Trust

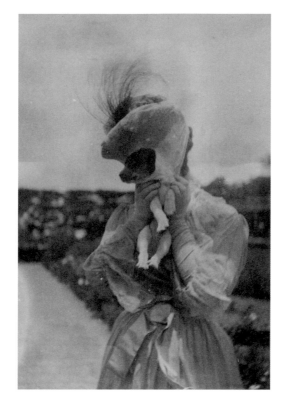

24. Isabella and a Fox Terrier Puppy, from Guest Book Volume III, p. 52, Summer 1897

humanized them. Photos of King Edward with Caesar—the rotund royal with his diminutive canine companion—tone down his strict public persona and make the monarch appear a touch less formal.

Seeing Isabella with her dogs teaches us something about her character. She was an intelligent and formidable person and could sometimes be intimidating, according to the recollections of those who knew her. However, pictures of her with her beloved pets show a different side of her personality. She was funny and playful and loved a cute puppy as much as anyone else (fig. 23). Isabella Stewart Gardner was many things—including a dog person (fig. 24).

OPPOSITE
23. Isabella and Kitty Wink with Giuseppe Della Gherardesca, from Guest Book Volume VI, inside back cover, 20 July 1902

Notes

1 Morris Carter, *Isabella Stewart Gardner and Fenway Court* (Boston: Houghton Mifflin, 1925), p. 144 for ownership of horses; pp. 160–61 for lion.

2 Isabella's will was first drafted in 1913. She revised it a handful of times before her death in 1924. The final version was probated on 23 July 1924 and is preserved in the Massachusetts Supreme Judicial Court Archives. The Cotting School is named in Isabella's will by its earlier designation, the Industrial School for Crippled and Deformed Children, which it retained from 1893 to 1974.

3 Hugh Dalziel and John Maxtee, *The Fox Terrier, and All About It*, 2nd ed. (London: L.U. Gill, 1900), p. 1.

4 Isabella Stewart Gardner to Bernard Berenson, Green Hill, 25 May 1900, Bernard and Mary Berenson Papers, I Tatti Harvard Center for Renaissance Studies, Florence, Italy (hereafter cited as Berenson Papers).

5 Isabella Stewart Gardner to Bernard Berenson, 152 Beacon Street, 25 March [1898], Berenson Papers.

6 Isabella Stewart Gardner to Mary Berenson, Green Hill, 28 September 1904, Berenson Papers.

7 Isabella Stewart Gardner to Bernard Berenson, Green Hill, 26 October 1905, quoted in *The Letters of Bernard Berenson and Isabella Stewart Gardner, With Correspondence by Mary Berenson*, ed. Rollin Van N. Hadley (Boston: Isabella Stewart Gardner Museum, 2016), p. 369: "My beloved dog Kitty Wink had to be chloroformed because she was so very ill." From this reference, we know Kitty Wink died in the fall of 1905.

8 Carter, *Gardner and Fenway Court,* p. 245.

9 Carter, p. 247.

10 Carter, p. 247.

Photographic Credits

All photographs in the collection of the Isabella Stewart Gardner Museum,
unless otherwise noted.

Sean Dungan: fig. 1
Julia Featheringill Photography: cover, frontispiece, dedication, introduction, back cover,
figs. 3, 5, 7, 8, 9, 10, 11, 12, 20, 22, 23, 24
David Mathews: fig. 14
Royal Collection Trust / © Her Majesty Queen Elizabeth II 2020: fig. 21

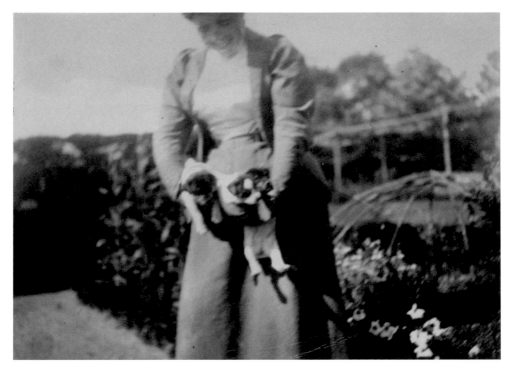

25. Isabella with Fox Terrier Puppies at Green Hill,
from Guest Book Volume IV, p. 16, August 1898